Shelli,
Just for
fun !
Happy B-day
my dear
friend :)
xo Vic
22

Synopsis

write your own ↓

Name:
weight:
Sex:
Colour

GRAPEFRUIT

A book of instructions + drawings by Yoko Ono

Introduction by John Lennon

Simon & Schuster

New York • London • Toronto • Sydney

SIMON & SCHUSTER
Rockefeller Center
1230 Avenue of the Americas
New York, NY 10020

SIMON & SCHUSTER and colophon are registered
trademarks of Simon & Schuster, Inc.

Manufactured in the United States of America

23 25 27 29 30 28 26 24

Library of Congress Cataloging-in-Publication Data is available

ISBN-13: 978-0-7432-0110-0
ISBN-10: 0-7432-0110-8

Publisher's Note

Grapefruit was originally published in a limited
edition of 500 copies by the Wunternaum Press
in Tokyo in 1964.

The 1970 edition contained material from the original,
and pieces and drawings done in subsequent years
by Yoko Ono.

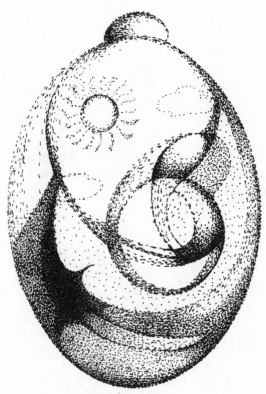

Open this bottle.

Y.O.

Once upon a thyme, Kind told Keen that she must tell a gory, every naught, to ease his heavy blind. Her head would troll if she hadn't. Instead, Keen gave Kind sheep of paper with some destructions. After 365 hits of this, Kind was a happy mane and Keen was a proud womb. Together, they roved and laughed forever after. Who could frame them. Hi! y.o. '00

INTRODUCTION by John Lennon

Hi! My name is John Lennon
I'd like you to meet Yoko Ono.

JOHN LENNON AS A YOUNG CLOUD

Theatre Piece

scene 1) Open and close inside John's head.
scene 2) Open and close other people's head.
scene 3) Open and close sky.

1968 spring

Where do you want to spend eternity?
 —a stone in Wales

THEATRE
Scene 1

I was reading over my shoulder
hearing nobody answer the bell.

Place: darkshaded living room
 of a brownstone building
 in upper west-side New York.

Time: Summer afternoon, 1971

1

MUSIC

LET'S PIECE I

500 Noses are more beautiful than
one nose. Even a telephone no. is more
beautiful if 200 people think of
the same number at the same time.

a) let 500 people think of the same
 telephone number at once for a
 minute at a set time.
b) let everybody in the city think
 of the word "yes" at the same time
 for 30 seconds. Do it often.
c) make it the whole world thinking
 all the time.

1960 spring

SECRET PIECE

Decide on one note that you want to play.
Play it with the following accompaniment:

The woods from 5 a.m. to 8 a.m.
in summer.

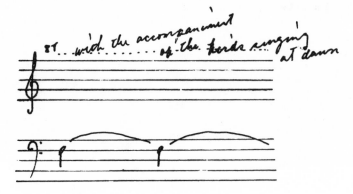

1953 summer

LAUGH PIECE

Keep laughing a week.

1961 winter

COUGH PIECE

Keep coughing a year.

1961 winter

VOICE PIECE FOR SOPRANO

Scream.
 1. against the wind
 2. against the wall
 3. against the sky

1961 autumn

PIECES FOR ORCHESTRA

No. 1

Peel

No. 2

Peek

No. 3

Take off

1962 summer

PIECES FOR ORCHESTRA

No. 4

Tear

No. 5

Touch

No. 6

Rub

1962 autumn

A PIECE FOR ORCHESTRA

Count all the stars of that night
by heart.
The piece ends when all the orchestra
members finish counting the stars, or
when it dawns.
This can be done with windows instead
of stars.

1962 summer

WALL PIECE FOR ORCHESTRA to Yoko Ono

Hit a wall with your head.

1962 winter

BUILDING PIECE FOR ORCHESTRA

Go from one room to another
opening and closing each door.
Do not make any sounds.
Go from the top of the building
to the bottom.

1963 winter

DRINKING PIECE FOR ORCHESTRA

Imagine letting a goldfish swim across
the sky.
Let it swim from the West to the East.
Drink a liter of water.
Imagine letting a goldfish swim across
the sky.
Let it swim from the East to the West.

1963 spring

BODY SOUND TAPE PIECE

Make body sound tapes of different
people at different times.
Of the old, young, crying, longing,
excited, calm, doubtful, etc.

1964 spring

TAPE PIECE I

Stone Piece

Take the sound of the stone aging.

TAPE PIECE II

Room Piece

Take the sound of the room breathing.

 1) at dawn
 2) in the morning
 3) in the afternoon
 4) in the evening
 5) before dawn

Bottle the smell of the room of that
particular hour as well.

1963 autumn

TAPE PIECE III

Snow Piece

Take a tape of the sound of the snow
falling.
This should be done in the evening.
Do not listen to the tape.
Cut it and use it as strings to tie
gifts with.
Make a gift wrapper, if you wish, using
the same process with a phonosheet.

1963 autumn

TAPE PIECE IV

Moving Piece

Take a tape of the sound of the stars
moving.
Do not listen to the tape.
Cut it and give it out to the people
on the street.
Or you may sell it for a moderate price.

1963 autumn

TAPE PIECE V

Comb Piece (a)

Take a tape of your wife combing
every day.
Keep it.
Bury it with her when she dies.

Comb Piece (b)

Take a tape of your husband combing
every day.
Keep it.
Play it after he dies.

Comb Piece (c)

Take a tape of your child combing.
Let her listen to it when she is
sick in bed.

1963 autumn

FISH PIECE

Take a tape of the voices of fish
on the night of a full moon.
Take it until dawn.

1964 spring

OVERTONE PIECE

Make music only with overtones.

1964 spring

CLOCK PIECE

Listen to the clock strokes.
Make exact repetitions in your head
after they stop.

1963 autumn

COLLECTING PIECE

Collect sounds in your mind that
you have overheard through the week.
Repeat them in your mind in different
orders one afternoon.

1963 autumn

SNORING PIECE

Listen to a group of people snoring.
Listen till dawn.

1964 spring

BELL PIECE

Listen to a bell for an hour.
Diminish the sound to piano
by ringing it over in your head.
Diminish the sound to pianissimo
by ringing it over in your dream.
Diminish the sound poco a poco
troppo pianissimo by forgetting.

Try other sounds
 i.e., mother's voice
 baby cry
 husband's hysterics

1963 autumn

ECHO TELEPHONE PIECE

Get a telephone that only echoes back
your voice.
Call every day and talk about many
things.

1964 spring

BICYCLE PIECE FOR ORCHESTRA

Ride bicycles anywhere you can in
the concert hall.
Do not make any noise.

1962 autumn

BEAT PIECE

Listen to a heart beat.

1963 autumn

PULSE PIECE

Listen to each other's pulse by
putting your ear on the other's
stomach.

1963 winter

EARTH PIECE

Listen to the sound of the earth turning.

1963 spring

WATER PIECE

Listen to the sound of the underground
water.

1963 spring

WATER PIECE

Steal a moon on the water with a bucket.
Keep stealing until no moon is seen on
the water.

1964 spring

DAWN PIECE

Take the first word that comes across
your mind.
Repeat the word until dawn.

1963 winter

ROOM PIECE I

Stay in a room for a week.
Do not take anything except water.
Have someone whisper to you in
the end of the week.

ROOM PIECE II

Stay in a room for ten days.
Do not eat.
Smoke.
Whisper to each other in the
end of the ten days.

1963 winter

ROOM PIECE III

Stay in a room for a month.
Do not speak.
Do not see.
Whisper in the end of the month.

1963 winter

BACK PIECE I

Put the light out.
Stand behind a person for four hours.

BACK PIECE II

Put the light out.
Walk behind a person for four hours.

1961 winter

LINE PIECE I

Draw a line.
Erase the line.

LINE PIECE II

Erase lines.

LINE PIECE III

Draw a line with yourself.
Go on drawing until you disappear.

1964 spring

CONCERT PIECE

When the curtain rises, go hide
and wait until everybody leaves
you.
Come out and play.

1963 autumn

HIDE-AND-SEEK PIECE

Hide until everybody goes home.
Hide until everybody forgets about you.
Hide until everybody dies.

1964 spring

WALKING PIECE

Walk in the footsteps of the person
in front.

 1. on ground
 2. in mud
 3. in snow
 4. on ice
 5. in water

Try not to make sounds.

1964 spring

CITY PIECE

Walk all over the city with an empty
baby carriage.

1961 winter

CITY PIECE

Step in all the puddles in the city.

1963 autumn

WIND PIECE

Blow hats all over the city.

1962 autumn

SNOW PIECE

Think that snow is falling.
Think that snow is falling everywhere
all the time.
When you talk with a person, think
that snow is falling between you and
on the person.
Stop conversing when you think the
person is covered by snow.

1963 summer

TWO SNOW PIECES
 for solo or trio

No. 1

Watch snow fall until dinner time.

No. 2

Watch snow fall until it covers thirty-three
buildings.

1964 spring

THREE MORE SNOW PIECES
 for solo or orchestra

No. 1

Send snow sounds to a person you like.

No. 2

Walk in the snow without making footprints.

No. 3

Find a hand in the snow.

1964 spring

WOOD PIECE

Use any piece of wood.
Make different sounds by using different
angles of your hand in hitting it. (a)
Make different sounds by hitting
different parts of it. (b)

1963 autumn

STONE PIECE

Find a stone that is your size or weight.
Crack it until it becomes fine powder.
Dispose of it in the river. (a)
Send small amounts to your friends. (b)
Do not tell anybody what you did.
Do not explain about the powder to the
friends to whom you send.

1963 winter

TUNAFISH SANDWICH PIECE

Imagine one thousand suns in the
sky at the same time.
Let them shine for one hour.
Then, let them gradually melt
into the sky.
Make one tunafish sandwich and eat.

1964 spring

WALL PIECE I

Sleep two walls away from each other.
Whisper to each other.

1963 autumn

WATER PIECE

Water.

1964 spring

PURIFICATION CHAMBER PIECE—for a person
who claims to suffer from complexity of
the mind or schizophrenia.

Build a room where you do nothing but
stand and carry a stone until it's
unbearable. You will soon find that your
thoughts are purified to the point of
thinking only about the weight of the stone.

1968 winter

2 PAINTING

PART PAINTING

Series 5

congratulations!

you are one of the
10,000 selected
people to whom we
are sending this
part painting by
yoko ono. each
person has received
a portion
of this painting.
we are planning to
hold a gathering in
the future to put all
parts together to
appreciate the
painting in its
original form. but
meanwhile, you may
recommend us select
names to send parts
as there are a few
still in our hand.
it is important that
you mention in your
letter the social
position of your
friend, as the size
of the portion will be
decided accordingly.

SERIAL NO.
#9,331

PAINTING IN THREE STANZAS

Let a vine grow.
Water every day.

The first stanza — till the vine spreads.
The second stanza — till the vine withers.
The third stanza — till the wall vanishes.

1961 summer

PIECE FOR THE WIND

Cut a painting up and let them be lost
in the wind.

1962 summer

PAINTING FOR THE WIND

Cut a hole in a bag filled with seeds
of any kind and place the bag where
there is wind.

1961 summer

PAINTING FOR THE WIND

Make a hole.
Leave it in the wind.

1961 autumn

PAINTING TO SEE THE SKIES

Drill two holes into a canvas.
Hang it where you can see the sky.

(Change the place of hanging.
Try both the front and the rear
windows, to see if the skies are
different.)

1961 summer

PAINTING FOR THE SKIES

Drill a hole in the sky.
Cut out a paper the same size
as the hole.
Burn the paper.
The sky should be pure blue.

1962 summer

A PAINTING TO SEE THE SKY III

See the sky between a woman's thighs.
See the sky between your own thighs.
See the sky through your belongings
by making holes in them.

i.e., pants, jacket, shirt, stockings, etc.

1962 autumn

PAINTING TO LET THE EVENING LIGHT GO THROUGH

Hang a bottle behind a canvas.
Place the canvas where the west light
comes in.
The painting will exist when the bottle
creates a shadow on the canvas, or it does
not have to exist.
The bottle may contain liquor, water,
grasshoppers, ants or singing insects, or
it does not have to contain.

1961 summer

PAINTING TO SEE THE ROOM

Drill a small, almost invisible, hole
in the center of the canvas and see
the room through it.

1961 autumn

SHADOW PIECE

Put your shadows together until
they become one.

1963

CUT PIECE

Throw it off a high building.

1962 summer

A PLUS B PAINTING

Cut out a circle on canvas A. Place a
numeral figure, a roman letter, or a
katakana on canvas B on an arbitrary
point.
Place canvas A on canvas B and hang
them together.
The figure on canvas B may show, may show
partially, or may not show.
You may use old paintings, photographs, etc.
Instead of blank canvases.

1961 autumn

A PLUS B PAINTING

Let somebody other than yourself cut out
a part of canvas A.
Paste the cut out piece on the same point
of canvas B.
Line up canvas A and canvas B and hang them
adjacent to each other.
You may use blank canvases or paintings or
photographs to do this piece.

1961 autumn

PAINTING UNTIL IT BECOMES MARBLE

Cut out and hang a painting, design,
a photograph, or a writing (printed or
otherwise), that you like.
Let visitors cut out their favorite
parts and take them.
For example, if the visitor likes red,
let him take all the red parts.
Ask many visitors to cut out their
favorite parts until the whole thing is
gone.
Also, instead of cutting the parts out,
you may ask them to paint black ink over
them.
In case of the writing, you ask the
visitor to cut out his favorite letter
or word.

1961 summer

PAINTING TO ENLARGE AND SEE

1961 summer

PAINTING TO EXIST ONLY WHEN IT'S
COPIED OR PHOTOGRAPHED

Let People copy or photograph your
paintings.
Destroy the originals.

1964 spring

PAINTING TO HAMMER A NAIL

Hammer a nail in the center of a piece
of glass. Send each fragment to an
arbitrary address.

1962 spring

PAINT TO EXIST
COPIE TO

Let h ar pi

nails

1964

PAINTING TO HAMMER A NAIL

Hammer a nail into a mirror, a piece of
glass, a canvas, wood or metal every
morning. Also, pick up a hair that came
off when you combed in the morning and
tie it around the hammered nail. The
painting ends when the surface is covered
with nails.

1961 winter

BLOOD PIECE

Use your blood to paint.
Keep painting until you faint. (a)
Keep painting until you die. (b)

1960 spring

WATERDROP PAINTING

Let water drop.
Place a stone under it.
The painting ends when a hole is drilled
in the stone with the drops,
You may change the frequency of the water-
drop to your taste.
You may use beer, wine, ink, blood, etc.
instead of water.
You may use typewriter, shoes, dress, etc.
instead of stone.

1961 autumn

PAINTING TO SHAKE HANDS
(painting for cowards)

Drill a hole in a canvas and put your
hand out from behind.
Receive your guests in that position.
Shake hands and converse with hands.

1961 autumn

TIME PAINTING

Make a painting in which the color
comes out only under a certain light
at a certain time of the day.
Make it a very short time.

1961 summer

PAINTING FOR THE BURIAL

On the night of the full moon, place
a canvas in the garden from 1 a.m. till
dawn.
When the canvas is dyed thoroughly in
rose with the morning light, dismember
or fold it and bury.

The ways of burial:

　　1) Bury it in the garden and place a marker with a number on it.
　　2) Sell it to the rag man.
　　3) Throw it in the garbage.

1961 summer

SMOKE PAINTING

Light canvas or any finished painting
with a cigarette at any time for any
length of time.
See the smoke movement.
The painting ends when the whole
canvas or painting is gone.

1961 summer

PAINTING TO BE SLEPT ON

Hang it after sleeping on it for more
than 100 nights.

1962 summer

PAINTING TO BE STEPPED ON

Leave a piece of canvas or finished
painting on the floor or in the street.

1960 winter

PAINTING TO BE WATERED

Water every day.

1962 summer

PAINTING TO BE WORN

Cut out jackets or dress from acquired
paintings, such as Da Vinci, Raphael,
De Kooning. You may wear the painted
side in or out.
You may make underwears with them as well.

1962 summer

KITCHEN PIECE

Hang a canvas on a wall.
Throw all the leftovers you have
in the kitchen that day on the
canvas.
You may prepare special food for
the piece.

1960 winter

PAINTING FOR A BROKEN SEWING MACHINE

Place a broken sewing machine in
a glass tank ten or twenty times
larger than the machine. Once a year
on a snowy evening, place the tank
in the town square and have everyone
throw stones at it.

1961 winter

MEND PAINTING

Pick an old scarred painting.
Wash it thoroughly with soap.
Powder it. (This process may be eliminated
according to your taste.)
Perfume it.
The perfume may be a cheap one or an
expensive one, depending on your taste.
The time should be in the evening before
the lights are lit.
You should go near the window and do it
if it becomes too dark.
You may use an old wall, pavement, shoes,
gloves instead of a painting.

1962 summer

CANNON PIECE

Paste your name on the window.
Borrow a cannon.
Go to a distance and fire against
your name.

The name can be a name or a number
taken out at random from a telephone
book.

If a cannon is not available, you may
use machine-guns, arrows, stones,
spitting, urinating, hose-water, or
any other method.

If nothing is available, go and watch
until the name becomes unrecognizable
by sunset.

You may use telescopes to watch.

1963 autumn

KITE PIECE I
Borrow the Mona Lisa from the gallery.
Make a kite out of it and fly.
Fly it high enough so the Mona Lisa
smile disappears. (a)
Fly it high enough so the Mona Lisa
face disappears. (b)
Fly it high enough so it becomes a dot. (c)

KITE PIECE II
Every year on a certain day, collect
old paintings such as De Kooning, Klein,
Pollack.
Make kites with them and fly.
Fly them high enough and cut the strings
so they will float.

KITE PIECE III
Enlarge your photograph(s) and make many
kites and fly.
When the sky is filled with them, ask
people to shoot.
You may make balloons instead of kites.

1963 autumn

POSITION PIECE

Take one of the yoga positions and
see the painting that you like for
two days.
Your position can be at any distance
or direction from the painting.
Destroy the painting after the two
days.
You may do it with a photograph, a
mirror, or a person instead of a
painting.

1963 summer

SLEEPING PIECE I

Write all the things you want to do.
Ask others to do them and sleep
until they finish doing them.
Sleep as long as you can.

SLEEPING PIECE II

Write all the things you intend to do.
Show that to somebody.
Let him sleep for you until you
finish doing them.
Do for as long as you can.

1960 winter

PORTRAIT OF MARY

Send a canvas to a Mary of any country
and have her paste her photograph.
Have her send the canvas to the next
Mary of any country to do the same.
When the canvas is filled up with
photographs of Marys, it should be
sent back to the original sender.
The name does not have to be Mary.
It, also, can be a fictional name, in
which case the canvas will be sent to
different countries until a person with
such a name will be found. The object to
paste on the canvas does not have to be
a photograph. It can be a numeral figure,
an insect or a finger print.

1962 spring

STOMACH PIECE

Count the wrinkles on each other's
stomach.
Put a canvas on the wall of your
bed room with the number of both
persons' wrinkles added.

You may also use this number in place
of your name and put it on your name
card or your door.

1962 summer

PAINTING TO BE CONSTRUCTED IN YOUR HEAD

Observe three paintings carefully.
Mix them well in your head.

1962 spring

PAINTING TO BE CONSTRUCTED IN YOUR HEAD

Hammer a nail in the center of a piece
of glass. Imagine sending the cracked
portions to addresses chosen arbitrarily.
Memo the addresses and the shapes of the
cracked portions sent.

1962 spring

PAINTING TO BE CONSTRUCTED IN YOUR HEAD

Imagine dividing the canvas into twenty
different shapes. Make the exact model
of each piece and send it to an address
arbitrarily chosen. Write the twenty
addresses and the corresponding shapes
of the pieces on the back of the canvas.

1962 spring

PAINTING TO BE CONSTRUCTED IN YOUR HEAD

Imagine a flower made of hard material
such as gold, silver, stainless steel,
tin, marble, copper, etc.
Imagine it so that you can count each
of the thousand petals of the flower.
Imagine that the petals suddenly
became soft like cotton or like living
flesh.
In three hours, prick all the petals.
Save one and press it in a book.
In the margin of the page where the
petal is pressed, note the derivation
of the petal and the name of the petal.
At least eight hours should be spent
for the construction of the painting.

1962 summer

COLOR PIECE

Visual world not exactly shaped—
Sense of smell, anticipation, senses that
are not exactly shaped—
Dark shadows casted—
Rat colors with faint hairly smells and pale
dark spots like those on a transparent sheet
of celluloid—
Rose color with a glitter and softness that
is cool and motional—
The kind of color that does not exist by
itself but only when it is casted between
two moving objects—
The color like a remaining stain of illusion
on a moving object—
The color that only happens when movements
cut the air in a certain way and go immediately.
Use such color to tint your absent thoughts.
Have absent thoughts for a long time.

1964 summer

RUBBER PIECE

Imagine your body spreading rapidly
all over the world like thin tissue.
Imagine cutting out one part of the
tissue.
Cut out the same size rubber and hang
it on the wall beside your bed.

1964 spring

3 EVENT

TWO TELEGRAMS

1) COMING THIS MORNING WITH SPRING AIR
 LOVE

2) CANNOT BELIEVE YOUR STUPIDITY
 BELIEVING I WOULD ACTUALLY COME
 STOP YOU KNOW I DONT HAVE A CENT
 STOP COME MEANING COME LIKE IN BED
 STOP DONT CALL COLLECT ANYMORE AS
 PHONE BILL HOPELESSLY HIGH

dotted Line Event I

A follow the above dotted line to
make a sky

Ⓑ follow the above dotted line to make a sky

London winter '67
Tra la la

LIGHTING PIECE

Light a match and watch till it goes out.

1955 autumn

CENTRAL PARK POND PIECE

Go to the middle of the Central Park
Pond and drop all your jewelry.

1956 autumn

PEA PIECE

Carry a bag of peas.
Leave a pea wherever you go.

1960 winter

SMELL PIECE I

Send the smell of the moon.

1953 autumn

SMELL PIECE II

Send a smell to the moon.

1962 winter

MESS PIECE

Use things until they melt.
Wipe your sticky fingers after you use them.

Use things until they evaporate.
Drink water after you use them.

Use things until they become dry and hard.
Make a flute out of them.

1964 summer

WHISPER PIECE

a) Whisper. Ask the wind to take it to the
end of the world.

b) Whisper to the clouds. Ask them to remember
it.

c) Whisper what happened that day to the
reeds. Weave a pair of sandals with them and
send it to a friend.

d) Whisper all your secret thoughts to a tree.
Make a guitar out of it and send it to a
woman.

e) Whisper a secret to a young tree. Make a
chair out of it and send it to a man.

f) Whisper your name to a stone. Send it to
a stranger.

g) Whisper the first word that came to you
to a person next to you.

1961 spring

SMELL PIECE

Use a name card without a name.
Put an address and a smell instead.

SMELL PIECE

Send smell signals by wind.

1963 summer

ANNOUNCEMENT PIECE I

Give death announcements each time you
move instead of giving announcements of
the change of address.
Send the same when you die.

1962 summer

ANNOUNCEMENT PIECE II

Give a moving announcement each time
you die.

1963 summer

FLY PIECE

Fly.

1963 summer

CLOUD PIECE

Imagine the clouds dripping.
Dig a hole in your garden to
put them in.

1963 spring

MAP PIECE

Draw an imaginary map.
Put a goal mark on the map where you
want to go.
Go walking on an actual street according
to your map.
If there is no street where it should be
according to the map, make one by putting
the obstacles aside.
When you reach the goal, ask the name of
the city and give flowers to the first
person you meet.
The map must be followed exactly, or the
event has to be dropped altogether.

Ask your friends to write maps.
Give your friends maps.

1962 summer

MAP PIECE

Draw a map to get lost.

1964 spring

MASK PIECE I

Make a mask larger than your face.
Polish the mask every day.
In the morning, wash the mask instead
of your face.
When somebody wants to kiss you,
let the person kiss the mask instead.

1961 winter

MASK PIECE II

Make a mask smaller than your face.
Let it drink wine instead of you.

1962 summer

CONVERSATION PIECE (or Crutch Piece)

Bandage any part of your body.
If people ask about it, make a story
and tell.
If people do not ask about it, draw
their attention to it and tell.
If people forget about it, remind
them of it and keep telling.
Do not talk about anything else.

1962 summer

PENCIL LEAD PIECE

Imagine your head filled with pencil leads.
Imagine one of them broken.
Show a pencil lead to your friend and tell
him that it came out of your head.

1962 summer

RIDING PIECE

Ride a coffin car all over the city.

1962 winter

SUN PIECE

Watch the sun until it becomes square.

1962 winter

WALK PIECE

Stir inside of your brains with a penis
until things are mixed well.
Take a walk.

1961 winter

LAUNDRY PIECE

In entertaining your guests, bring out your
laundry of the day and explain to them about
each item. How and when it became dirty and
why, etc.

1963 summer

COUNTING PIECE I

Count the numbers of lights in the city
every day.
Make a number list and hang it on the
wall.

COUNTING PIECE II

Count the numbers of stars in the sky
every day.
Make a number list and send it to
your friends.

COUNTING PIECE III

Count the numbers of wrinkles on your
face or your body or certain parts of
your body. Send it to your friend in
place of a letter.

1962 winter

CLOCK PIECE

Make all the clocks in the world fast by
two seconds without letting anyone know
about it.

1963 autumn

CLOCK PIECE

Maybe the main clock of the world went fast
or slow by a second without anybody knowing
about it.
As long as people do not know about it,
nothing is disturbed.

CLOCK PIECE

Steal all the clocks and watches
in the world.
Destroy them.

1963 summer

CLOCK PIECE

Take all the clocks and watches in the town.
Set each one to an arbitrary time, arbitrarily,
or according to a system that you make. Any
system is acceptable as long as none of the
clocks are intentionally set to the correct time.

1963 summer

CLOCK PIECE

Select a clock.
Set it on time.
You may rewind the clock but never
reset it.
Call it your life clock.
Live accordingly.

1964 spring

THROWING PIECE

Throw a stone into the sky high enough
so it will not come back.

1964 spring

SMOKE PIECE

Smoke everything you can.
Including your pubic hair.

1964 spring

CARD PIECE I

Walk to the center of your Weltinnenraum.
Leave a card.

CARD PIECE II

Cut a hole in the center of your
Weltinnenraum.
Exchange.

CARD PIECE III

Shuffle your Weltinnenraums.
Hand one to a person on the street.
Ask him to forget about it.

1964 spring

CARD PIECE IV

Place a stone on each one of the
Weltinnenraums in the world.
Number them.

CARD PIECE V

Play rummy with your Weltinnenraums.
Play for money.
Play solitaire with your Weltinnenraums.
Play for death.

1964 spring

CARD PIECE VI

Find a card in your Weltinnenraum.

CARD PIECE VII

Open a window of one of the houses in
your Weltinnenraum.
Let the wind come in.

1964 spring

MIRROR PIECE

Instead of obtaining a mirror,
obtain a person.
Look into him.
Use different people.
Old, young, fat, small, etc.

1964 spring

ROOM PIECE

When a room is needed, obtain a person instead
of a room.
Live on him.
When another room is needed, obtain another
person instead of another room.
Live on them.

1964 spring

BOX PIECE

Buy many dream boxes.
Ask your wife to select one.
Dream together.

1964 spring

MASK PIECE

Wear a blank mask.
Ask people to put in wrinkles, dimples,
eyes, mouth, etc., as you go.

1964 spring

FLY PIECE

Skin two thousand balloons.
Fly them in the air.

1964 spring

PLANE PIECE

Hire a plane.
Invite everybody.
Ask them to write a will to you before
boarding.

1964 spring

TRAVEL PIECE

Make a key.
Find a lock that fits.
If you find it, burn the house
that is attached to it.

1964 spring

PRESCRIPTION PIECE

Prescribe pills for going
through the wall and have only
the hair come back.

1964 spring

WEARING-OUT MACHINE

Ask a man to wear out various things
before you use them.
Such as:
Women
Clothes
Books
Apartments
Pianos
Typewriters

1964 spring

FALLING PIECE

Go outside of you.
Look at yourself walking down the street.
Make yourself tumble on a stone and fall.
Watch it.
Watch other people looking.
Observe carefully how you fall.
How long it takes and in what rhythm you fall.
Observe as seeing a slow motion film.

1964 spring

FOG PIECE I

Think of what the next person is thinking.

FOG PIECE II

Polish an orange.

FOG PIECE III

Send a fog to your friend.

1964 spring

NAME PIECE

Change your name by the period
of your age.
By the year.
By the day.
By occasions.
By the color of your dress.

1964 spring

LIGHT PIECE

Carry an empty bag.
Go to the top of the hill.
Pour all the light you can in it.
Go home when it is dark.
Hang the bag in the middle of your
room in place of a light bulb.

1963 autumn

CONVERSATION PIECE

Talk about the death of an imaginary
person.
If somebody is interested, bring out
a black framed photograph of the
deceased and show.
If friends invite you, excuse yourself
by explaining about the death of the
person.

1963 summer

HAND PIECE

Sit in the garden.
Raise one hand.
Extend it until it reaches a cloud.
Have your friend ring a symbol.
Keep extending it until it goes out
of the stratosphere.
Have your friend put a flag out.

1963 summer

ANIMAL PIECE

Take one mannerism from one kind of
animal and make it yours for a week.

Take another mannerism from another
kind of animal and make it yours
without dropping the previously
acquired mannerism.

Go on increasing mannerisms by
taking them from different kinds
of animals.

1963 summer

SKY EVENT for John Lennon

The organizer of the event may select one version from the following:

a) wait until a cloud appears and come above your head
b) wait until the snow falls
c) wait until a chair falls

All three versions can be done in any season of the year. People should gather with their Sunday outfit, wearing their best hats, etc.

If the weather is cold, burn fire, if it's warm pass cold drinks and wait.

Stop cars and people on the street and inform them of the event that's taking place. Let them join. Call friends and strangers on the phone and ask them to join.

Prepare binoculars and telescopes for people to occasionally check the sky. Ladders of great height should be prepared for people who wish to climb up high to check.

The gathering can take place both outside and indoors. If it's indoor, it will be nice to gather in a room with a large window. If it's a closed room, take turns to go out and check.

Take photographs of the sky, the town and the people, before, during and after the wait.

Do not talk loud or make noise, as you may scare the sky.

1968 spring

SKY Event II

(IMAGINARY SKY EVENT – refer to SKY EVENT for John LENNON)

Do the sky Event in your mind
THEN Go out into the street and take photos to document the event

If the sky event in your mind takes place in another city,
ask a friend in that city to take photos for you.

4 POETRY

born: Bird year
early childhood: collected skys
adolescence: collected sea-weeds
late adolescence: gave birth to a grapefruit
 collected snails, clouds, garbage
 cans, etc. Have graduated many
 schools specializing in these subjects
at present: traveling as a private lecturer of the
 above subjects and others.
recipient of Hal Kaplow Award

Statement:

People went on cutting the parts they do not like of me finally
there was only the stone remained of me that was in me but they
were still not satisfied and wanted to know what it's like in the stone.

 y.o.

P.S. If the butterflies in your stomach die, send
 yellow death announcements to your friends.

Written for the production of "STONE" at Judson Church Gallery,
New York, March 1966.

this part is light

this part is lighter

a butterfly was here

this part is not so clean

this part is visible

this part is very light

this part is very, very light

this part is heavier
than
←

a statue was here

this part is of better quality than
→

this part does not exist

on paper
y.o. '67 fall London

NUMBER PIECE I

Count all the words in the book
instead of reading them.

NUMBER PIECE II

Replace nouns in the book with numbers
and read.
Replace adjectives in the book with
numbers and read.
Replace all the words in the book with
numbers and read.

1961 winter

CHEWING GUM MACHINE PIECE

Place Chewing Gum Machines with
many different word cards in them
next to Coca-Cola Machines on
every street corner.
Make it so that a word card comes
out when you put one cent in.

Put more auxiliary words than nouns.
More verbs than adjectives.

1961 winter

PAPER FOLDING PIECE

Fold certain parts of a paper and read.
Fold a crane and read.

1963 winter

DOLLAR PIECE

Select an amount of dollar.
Imagine all the things that
you can buy with that amount.(a)
Imagine all the things that
you cannot buy with that amount.(b)
Write it on a piece of paper.

1963 spring

SYLLABLE PIECE

Decide not to use one particular
syllable for the rest of your life.
Record things happened to you in
result of that.

1964 spring

CLOSET PIECE I

Think of a piece you lost.
Look for it in your closet.

CLOSET PIECE II

Put one memory into one half of your head.
Shut it off and forget it.
Let the other half of the brain long for it.

CLOSET PIECE III

Kill all the men you have slept with.
Put the bones in a box and send it out into
the sea with flowers.

1964 spring

TOUCH POEM FOR GROUP OF PEOPLE

Touch each other.

1963 winter

TOUCH POEM

Give birth to a child.
See the world through its eye.
Let it touch everything possible
and leave its fingermark there
in place of a signature.

i.e., Snow in India
　　　J.C.'s overcoat
　　　Simone's equilibrium
　　　Clouds
　　　etc.

1963 summer

TOUCH POEM III

Hold a touch poem meeting at somewhere
in the distance or a fictitious address
on a fictitious day.

TOUCH POEM VI

Ask people to come.
Invite only dead people.

1964 spring

TOUCH POEM V

Feel the wall.
Examine its temperature and moisture.
Take notes about many different walls.

1963 autumn

A poem to be read with a magnefying glass

Y.O. '64 fall London

On Line

yo '67 London

——————————————— this is a straight line

——————————————— this is not so straight

——————————————— this line is a thousand miles long

——————————————— this line is an inch long

——————————————— this line has history

———————————— this line is smelly

———————————— this line is suffering

———————————— this line was once a circle

———————————— this line was a phoenix

———————————— this line was said to be a bit grey at one time

this line only comes out once every billion years

Name:
Age: Sex: Male Female
Occupation:
Please check the following
data:

1) I $\frac{\text{like}}{\text{dislike}}$ to draw circles.

2) I have $\frac{\text{always}}{\text{never}}$ drawn circles
 well.

3) I $\frac{\text{am}}{\text{was}}$ a better circle-
 now.
 drawer in the past.
 when I was (age).

Other comments regarding your
circle experience:

DRAW CIRCLE

Send to:

YOKO ONO

EMPIRE STATE BLDG.

N. Y. C. 1, N. Y.

MAILING PIECE I

Send a sound of a smile.

MAILING PIECE II

Send the sound of one hundred sun rising at once.

MAILING PIECE III

Send a wind around the world many times until it
becomes a very delicate breeze.

1962 summer

QUESTIONNAIRE

1966 spring

QUESTIONNAIRE

Name:_____
 (advised to include all the names you are called by.)
ADDRESS:_____
 past present future
AGE: I am at the age where:_____
SEX:_____

COLOUR:_____
HEIGHT:_____
WEIGHT:_____
OCCUPATION:_____
DISEASE:_____
PHYSICAL PECULIARITIES:_____

OTHER COMMENTS:_____

Date:_____
 Signature:_____

Answer the following questions True or False.

TRUTH/FALSE

The sixth finger is usually not used because it's existence is not physically perceivable.

There is a transparent peace tower in New York City which casts no shadow and, therefore, very rarely recognized.

Blood is not red unless exposed, and blue when it's imagined.

The structure of the American jury system is taken from the chance music operation by John Cage. (The noted Judge Connolly is said to have said "all verdicts are beautiful".)

Mt. Fuji, whose colour is blue and white from the distance and volcano red when you go near, is a carefully planned modern Japanese project built to attract American tourists.

The East Side is not a word to define its location but was originally a name of the town "The Wise East on the Wrong Side." Later it was shortened to the presently known "The East Side".

Your weight is twice mine, and height 5 inches shorter.

Grapefruit is a hybrid of lemon and orange.
Snow is a hybrid of wish and lament.

All fruits are related species of banana, which was the first fruit in existence. The Bible lied about the apple because they felt mentioning the word banana too undignified.

Roaches are moving forms of flowers, though visually they seem unconnected.

Happenings were first invented by Greek gods.

The word "manila envelope" comes from a deeply-rooted racial prejudice.

Coughing is a form of love.

All streets are invisible. The visible ones are fake ones, though some visible ones are the end parts of the invisible ones.

Teeth and bones are solid form of cloud.

Paper is marble cut so thin that it has become soft. (Make marble out of toilet paper.)

Plastic is a portion of sky cut out in solid form. (Collect many pieces of plastic and look through them to see if they look blue.)

If you wear a clothes long enough it becomes part of you and you will suffer from serious physical maladjustment when you take it off. A princess died from taking off vines that had covered her for ten years. A prince, when his encircling vines were removed, was found to be non-existent.

When you leave things, you leave your spirit behind, too. But if you don't leave them, you age.

Your brother is the man you killed in the past world. He was born in your family because he wanted to be near you.

There is a wish man in the corner of the world whose daily task is to send good-will waves to the world to clear the air.

Men used to walk on hands upside down, but they changed to the present form because it was considered less obscene.

99 per cent of the world is dead bodies and tombs. We are the remaining 1 per cent . . . (or are we?).

There are one thousand suns arising every day. We only see one of them because of our fixation on monistic thinking.

Piano keys are flower-petals turned hard.

People who bought Ono's "bagwear" invariably encountered fantastic good luck and fortune.—ad.

A cloud consists of the following substances: colour, music, smell, sleep and water. Sometimes it rains substances other than water, but very few people notice it.

A, B, OR C

Yellow Talk

 a) All colours are imaginary except yellow. Yellow is the colour of sun at its height. Other colours are shades of yellow in varying degrees which have been given different names, as if each of them exist independently, purely for idealogical purposes.—Dr. Song.

 b) Yellow is the only imaginary colour.—Dr. Suzuki.

 c) All colours have yellow in it.—Dr. Lee.

 d) All colours are imaginary.—Dr. Kato.

Youth Talk

 You are still young because:

 you never matured.
 you talk baby-talk to your husband/wife.
 your children say so.
 your grandchildren say so.
 your great grandchildren say so.
 you don't see any wrinkles on your face.
 you still hate the same friends.
 other reasons (give your reason).

Stone Talk
 Stone is a:
 noun.
 pronoun.
 verb.
 adverb.
 adjective.
 preposition.
 conjunction.
 interjection.

Star Talk
 The star Uranus is:
 blue.
 red.
 silver.
 green.
 white.
 rainbow colour.

Line Talk
 A line is a:
 sick circle.
 billion lines that are cluttered into a narrow space.
 unfolded word.
 aggressive dot.

Daisy Talk

The weight of a daisy is:
2 pounds less than your brains.
100 pounds plus a wind.
three feathers.
a drop of your mother's tear.
5 billion pounds minus the sea.

Wink Talk

An intensity of a wink is:
two cars smashed head on.
a storm turned into a breeze.
A water drop from a loose faucet.

Wind Talk

The age of the wind is:
A billion years older than the Empire State Building
Three hundred years older than the Alps.
A day younger than the sea.
A day older than the Christ.
Two months younger than your daughter.
Starting five months after your death.

Further information and the copy of the Questionnaire is included in the "Stone" pamphlet (50 cents).

SHOOT 100 PANES OF GLASS

When a person hurts you badly,
line up 100 panes of glass in
the field and shoot a bullet
through it.
Take a copy of a map made by
the cracks on each glass and
send a map a day for 100 days
to the person who has hurt you.

1966 fall

ONO'S SALES LIST
N.Y.C. 1965

ONO'S SALES LIST These Works (c) copyright 1965 by Yoko Ono

A. *SELF PORTRAIT*..$1–
 types:
 with frame...$5–

B. *SOUNDTAPE* of the
 SNOW FALLING AT DAWN...........................25c per inch
 types:
 a) snow of India.
 b) snow of Kyo.
 c) snow of AOS.

C. TOUCH POEMS* priced according to material $150– to $10,000–
 types:
 a) paper set.
 b) flower set.
 c) water set.
 d) hair set.
 e) cloud set.
 f) wind set.

D. Machines*
 types:
 a) *CRYING MACHINE*—machine drops tears and cries for you when coin is deposited..................................$3,000–
 b) *WORD MACHINE*—machine produces a word when coin is deposited...$1,500–
 c) *DISAPPEARING MACHINE*—machine that allows an object to disappear when button is pressed..............$1,600–

d) *DANGER BOX*—machine that you will never come back the same from if you get in (we cannot guarantee your safety in its use)..$1,100–

e) *SKY MACHINE*—machine produces nothing when coin is deposited..$1,500–

f) *ETERNAL TIME*—a beautiful *ETERNAL TIME CLOCK* that keeps eternal time..$800–

E. Architectural Works* (priced according to contractors' arrangements and cost of property).
types:

a) *LIGHT HOUSE*—a house constructed of light from prisms, which exists in accordance with the changes of the day.

b) *WIND HOUSE*—a house of many rooms designed so that the winds may blow through creating a different sound for each room.

c) *TRANSPARENT HOUSE*—a house intended so that the people inside cannot see out, and so that the people outside can see in.

F. Paintings
types:

a) *NAIL PAINTING......FLOWER PAINTING......SHADOW PAINTING*, and many other great do-it-yourself paintings...$50–

b) *PART PAINTING*—details upon request, contains ten thousand parts.............................$100– per 3 sq. inches

c) *INSTRUCTURE*—scores...............................50c a piece

d) *PAINTINGS TO BE CONSTRUCTED IN YOUR HEAD*—scores...50c a piece

G. *GARDEN SETS* (priced according to contractors' costs, stones, pebbles, etc.).
types:
a) a shallow hole for the moonlight to make a pond.
b) a deep hole for the clouds to drip in.
c) elongated hole for fog ways.
e) stone settings for the snow to cover.
f) stones and pebbles set like a dry river bed.

H. Letters
types:
a) letter to Ivan Karp...............................original...$300–
copies......50c
b) reply from Ivan Karp...........................original...... 2c
copies......50c

I. *EVENTS*
types:
a) to let pink snow fall and cover your town—guaranteed not to be artificial—score...$1–
performance...$2,000–
b) circle event.........................2″ x 3″......free upon request
40″ x 24″.....................$150–
c) hole event...........................2″ x 3″......free upon request
40″ x 24″.....................$150–

J. Record of Events—a complete record of all Events by Yoko Ono since 1951 with photographs and illustrations...................$7–

K. Dance Scores—twenty-five scores...................................$3–

L. Music Scores
 types:
 a) actual sound scores...50c
 b) *IMAGINERY MUSIC*—scores..................................75c
 c) opera scores...$1–
 d) *INSOUND MUSIC*—scores....................................$1.50

M. Underwear (custom made to order)
 types:
 a) special defects underwear for men—designed to accent your
 special defects....................................in cotton.......$10–
 in Vicuna......$175–
 b) *UNDERWEAR TO MAKE YOU HIGH*—for women,
 description upon request.......................about $10– to $35–

N. Books
 types:
 a) *GRAPEFRUIT*—published in Tokyo, July 4, 1964, a limited
 edition of 500 copies, in English and Japanese, over 200
 compositions in Music, Painting, Event, Poetry, and Object,
 since 1951...$10–
 b) *GRAPEFRUIT II*—over 200 compositions not published in
 GRAPEFRUIT, in Music, Painting, Event, Poetry, and
 Object (including *TOUCH POEMS*), to be published in 1966
 pre-publication price.......$5–
 post-publication price......$10–

O. *SIX FILM SCRIPTS*—includes *WALK TO THE TAJ
 MAHAL*...$3–

*Patents applied for, machines, and models for Architectural Works,
may be viewed by appointment, only written requests accepted.

POSTCARD

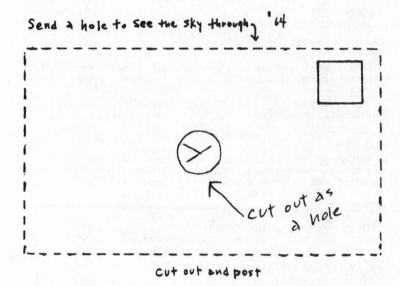

Send a hole to see the sky through. '64

5 OBJECT

REVALUE PIECE II

Use all existing art work as pieces of
furniture and household appliances.
i. e. Use sculpture such as Henry Moore's
as diaper hangers, or chairs, bookshelves,
tables and beds. Use paintings such as
Monet and Picasso as heavy curtains, sofa
covers, etc.

Use all existing armaments as decorative objects and
accessories. i. e. Use cannons and fighters for garden
sculptures, bullets and earrings, etc.

1968 winter

BURNING PIECE

Make different objects to burn.
The objects should be material and
complexed.
 i.e. autobiography
 embroidery
 mahjong set
 carved chair
 electric studio, etc.

Appreciate the difference of time it
takes to burn.
The piece is made when they become ashes.

Do not use ready-made objects to burn.

1960 spring

COLLECTING PIECE I

Select a subject.
Write five million pages (single space)
on the subject.

COLLECTING PIECE II

Put a person on the stage.
Examine the person as follows in all
possible detail.

1. Weigh
2. Measure
3. Count
4. Question
5. Dismember
6. Burn
7. Record

1963 spring

COLLECTING PIECE II

Break a contemporary museum into pieces
with the means you have chosen. Collect
the pieces and put them together again
with glue.

COLLECTING PIECE III

Break your mirror and scatter the pieces
over different countries.
Travel and collect the pieces and glue
them together again.
You may use a letter or a diary instead
of a mirror.
You may break a doll or an airplane a
thousand feet high in the sky over a
desert.

1963 autumn

VENUS OF MIRO PIECE

Hand out small portions to people who
come to see.
Ask them to polish them at home.
Ask them to bring them back in fifty
years to put the Venus together again.

1964 spring

CHIMNEY PIECE

Build three thousand chimnies and line them up
so it will look like one from a certain point
and three thousand from another point.

1964 spring

PIECE FOR THREE CHIMNIES

Build three chimnies.
Build them so that from a certain distant
point they look like one chimney, from
another point: like two and from another
point: like three.
Take pictures of the three different images.
You may build houses, temples, etc., instead
of chimnies.

1964 spring

TELESCOPE PIECE

Make a sculpture to put on a mountain
for people to see with telescopes.

1964 spring

SUPPORTING GOODS PIECE

Construct human body parts that function
better than what we have now (i.e., water-
proof, fire-proof, etc.).
Sell them in a supporting goods store for
a price.
Use ready-made objects that you can find
in your apartment.

1964 summer

SUPPLY GOODS STORE PIECE

Open a supply goods store where you
sell body supplies:

Tail
Hair
Lump
Hump
Horn
Halo
The third eye
etc.

1964 spring

LOCKET PIECE

Find a substance that is solid but becomes
liquid when it melts, and transparent but
stains when you put it on something.
Also, the weight should be immense or
constantly changing.
Put the substance in your locket in place
of a photograph.

1964 summer

6 FILM

These scores were printed and made
available to whoever was interested
at the time or thereafter in making
their own version of the films, since
these films, by their nature, became
a reality only when they were repeated
and realized by other film-makers.

A dream you dream alone may be a dream,
but a dream two people dream together
is a reality.

FILM SCRIPT 3

Ask audience to cut the part of the image on
the screen that they don't like.

Supply scissors.

— from SIX FILM SCRIPTS BY YOKO ONO, Tokyo,
 June 1964

FILM SCRIPT 5

Ask audience the following:
1) not to look at Rock Hudson, but only Doris Day.
2) not to look at any round objects but only square
and angled objects — if you look at a round object
watch it until it becomes square and angled.
3) not to look at blue but only red — if blue comes
out close eyes or do something so you do not see,
if you saw it, then make believe that you have not seen
it, or punish yourself.

— from SIX FILM SCRIPTS BY YOKO ONO, Tokyo,
 June 1964

OMNIBUS FILM

1) Give a print of the same film to many directors.
2) Ask each one to re-edit the print without leaving
out any of the material in such a way that it will
be unnoticed that the print was re-edited.
3) Show all the versions together omnibus style.

— from SIX FILM SCRIPTS BY YOKO ONO, Tokyo,
 June 1964

IMAGINARY FILM SERIES

SHI (From the cradle to the grave of Mr. So)

A slow film taken in the time space of 60 years, following a
person who's born and died. From about the 30th year, it
becomes a film of a couple, as the man gets married. It really
becomes "a film of waiting" towards the end since the film
obviously starts to have a senile quality in its camera work,
while the man in the film looks still robust. It is amazing that
the death came so suddenly over the man in a form of diarrhea.
Highly incredible film which makes one think. -- You never
know when you die.

A FILM OF SUPER-REALISM

SHI (From the cradle to the grave of Mr. So)

Interview with the director, Mr. Toyama.

Tell me, Mr. Toyama, you are relatively unknown in the film world, do you think it had something to do with the fact that you were devoted to the making of this film "SHI" (this is no misprint - means "death" in Japanese) of super-realism, as they call now?

Yes, definitely.

How long did it take for you to make this film?

Sisty years.

Incredible.

Well, you can say that, I suppose. But it could have been longer if he hadn't died then. I was lucky.

Now people are saying that this film will create a new move in the film world. Do you think that will happen?

It all depends on how you can outlive the film.

Yes, yes, I heard that in the end you were getting rather impatient, that you didn't know if you could wait until the death scene takes place. You didn't, of course, use any means to speed up the ending or anything?

No, no, everything took place naturally.

What was the cause of his death?

Diarrhea.

I understand that the film was backed by a Japanese Ketchup Company?

Yes, and that's why the whole thing has a pink tone to it. They wanted me to use a red theme that reminds you of ketchup, but I used pink instead. But I made sure that the blood would look like ketchup, and the ketchup like blood, showing that both substances were equally essential. The ketchup company liked that. Also, this gave a little surrealistic touch to the film, which, otherwise, would have been too realistic.

QUESTIONNAIRE FOR FILM NO. 4 aug. 21 '67 y. o.

NAME. _____
 last middle first others

AGE. _____ OCCUPATION. _____
SEX. _____

ADDRESS. _____
 past present future

COLOURS YOU LIKE. _____
COLOURS YOU DISLIKE. _____
DID YOU SEE ANY COLOUR IN THIS FILM? _____
ARE YOU COLOUR BLIND? _____

DID YOU SEE ANY HEXAGONAL IMAGES IN THE FILM? ___
WOULD YOU SAY THAT THERE WERE SUBLIMINAL MESSAGES
IN THIS FILM? _____

WOULD YOU SAY THAT YOU TEND TOWARDS BEING A
SIMPLE MINDED PERSON? _____
WOULD YOU SHOW THIS FILM TO YOUR MOTHER? _____
YOUR WIFE? _____ CHILDREN? _____

DID YOU FIND YOURSELF FOCUSING YOUR EYES ON
a) CENTER OF THE SCREEN? _____
b) ANY OTHER PART OF THE SCREEN (specify part) _____

DID YOU LIE ABOUT YOUR OCCUPATION? _____
 SEX? _____
IF SO, WHAT ARE YOU, REALLY? _____

DID YOU FEEL THAT THE FILM WAS TOO SHORT, IF SO,
HOW MUCH LONGER SHOULD IT BE? _____

DID YOU THINK THIS FILM WAS THE BEST FILM OF THE
a) YEAR ____ b) 20 CENTURY ____ c) DECADE ____ e) EVER __

WOULD YOU BE INTERESTED IN PERFORMING IN THIS FILM?

WOULD YOU SAY YOUR BACKSIDE WAS a) BEAUTIFUL? _____
b) UNIQUE? _____ c) CHARMING? _____ d) PLAIN? _____
e) OR? _____ f) WHAT COLOUR IS IT? _____
 (specify)
WHAT WOULD YOU SAY THIS FILM WAS ABOUT? _____

ANYTHING ELSE?

fill this in and mail it to yoko ono c/o international times.

7 DANCE

HAND PIECE

Raise your hand in the evening light
and watch it until it becomes transparent
and you see the sky and the trees through it.

BODY PIECE

Stand in the evening light until you
become transparent or until you fall
asleep.

1961 summer

AIR TALK

It's sad that the air is the only
thing we share.
No matter how close we get to each other,
there is always air between us.

It's also nice that we share the air.
No matter how far apart we are,
the air links us.

from Lisson Gallery brochure '67

DANCE PIECE FOR STAGE PERFORMANCE

Dance in pitch dark.
Ask audience to light a match if they want
to see.
A person may not light more than one match.

1961 autumn

DANCE PIECE

Have a dance party.
Let people dance with chairs.

1961 winter

13 DAYS DO-IT-YOURSELF DANCE FESTIVAL
(as it was done)

Send a pound for

YOKO ONO'S 13 DAYS DO-IT-YOURSELF DANCE FESTIVAL
TO BE HELD IN LONDON!

If you don't have a pound, send a pound worth of flowers and 13
stamps.

to: YOKO ONO DANCE COMPANY
25 Hanover Gate Mansions NW1

place: the Festival will take place in your mind
time: between Sept. 27 − Oct. 9 '67
your pound: with your pound, each day for 13 days, you will
 receive a card of dance instructions for the day
 and the time to perform the piece so we will be
 performing at the same time, all of us
method of performance: each member of the dance, thus, will
 communicate with the other members
 by mental telepathy

Dance Report

in the old east
there was a dance in which young girls
at the age of 12 or 13 wore special
intoxicating flowers inducing them to sleep
while standing. the girls went on
standing for hours while people
watched and appreciated the
delicate swaying of the
bodies.

1st day

midnight

breathe

breathe

at dawn

2nd day

3rd day
in the evening

breathe together

watch

draw a large circle in the sky
let us know the diameter of the
circle (guess), direction and the
color of the sky you were watching
and the duration of your watching experience

4 th day
in the afternoon

watch

go to the nearest fountain
and watch the water dance

afternoon

5th day

count

count the clouds
name them

8th day (afternoon)

shake

go shake hands with as many
persons as possible. write
down their names. try in the
elevator, tube, escalator,
street, toilet, on top of a
mountain, in the dark, daydream,
on the clouds, etc. make it a
nice handshake by holding a
flower in your hand, perfume or
wash your hand, etc.

9th day
afternoon

——————————————————————————————

6th day evening

watch

have you seen a horizon lately?
go see a horizon. measure it
from where you stand and let us
know the length.

8th day 8p.m.

watch

boil water and watch until it
evaporates

YOKO ONO DANCE CO. ☆ WATER 13 DAYS DANCE FESTIVAL London 1967 no no no no no no

10th day morning

find

go find a clover and send us
measurements weight of all
possible parts of the clover

send

send something you can't count

11 th day
daylight

12th day
dreamtime

SWIM

SWIM IN YOUR DREAM AS FAR AS
YOU CAN UNTIL YOU FIND AN
ISLAND. TELL US RESULTS.

13 th day
future time

color yourself
wait for the spring to come
let us know when it comes

YOKO ONO DANCE Co. 13 DAYS DANCE FESTIVAL COPYRIGHT YOKO ONO 4 spring trotoro...

Dance Report — <u>on facing</u>

face the wall throughout the year
and imagine banging your head
against it: a) slowly until the
wall collapses and you see the sky.
b) violently until your head is
gone.

consider if it is such a catastrophe
to live without your head or if it
shouldn't be easier for you to go
around since your body would be much
lighter.

water talk

you are water
I'm water
we're all water in different containers
that's why it's so easy to meet
someday we'll evaporate together

but even after the water's gone
we'll probably point out to the containers
and say, "that's me there, that one."
we're container minders

For Half-A-Wind Show, Lisson Gallery, London 1967.

Dance Report — <u>on hiding</u>

hide in the cupboard
a) until your family starts to wonder
b) until your family forgets you
(make choice)

YOKO ONO & DANCE CO. 13 DAYS DANCE FESTIVAL COPYRIGHT YOKO ONO & Cupboard sisi

Dance Report – <u>on floating</u>
(or how to make the city
so light that it floats
away in the sky)

Carry a stone. Go on
carrying heavier stones
until they become so
heavy that the whole
city starts to look
lighter than what you
are carrying.

YOKO ONO & DANCE COMPANY 13 DAYS DANCE FESTIVAL IN YOUR MIND © 1967 YOKO ONO

INFORMATION

RECORD OF 13 CONCERT PIECE PERFORMANCES
. . .since most pieces consist of
just titles or very short instructions,
passing words as to how they were
performed previously has become a habit . . .

HIDE PIECE

Hide.

This piece was first performed in New York, Carnegie Recital Hall, 1961, by completely turning off the light in the concert hall including the stage and a girl hiding in a large canvas sheet on the stage while two men made soft voice accompaniment. In 1962, Tokyo, also in total darkness, performers hid behind various things on the stage, while a male solo performer struggled to get out of a bag on the stage he was put in. In New York, 1965, performers and audience, using Canal Street subway station as a place of performance, hid from each other by using their own methods. In London, 1966, Jeanette Cochrane Theatre, Yoko Ono brought out a 3 foot pole on the center of the stage and hid behind it ½ hr.

SWEEP PIECE

Sweep.

This was first performed 1962 in Tokyo, Sogetsu Art Center
by a solo male performer during 4 hour concert of works by
Yoko Ono. The performer covered the areas all around and
in the concert hall. It was performed again 1966 London,
Jeanette Cochrane Theatre, as a solo piece by Yoko Ono,
sweeping from one end of the stage to another.

CUT PIECE

Cut.

This piece was performed in Kyoto, Tokyo, New York and London. It is usually performed by Yoko Ono coming on the stage and in a sitting position, placing a pair of scissors in front of her and asking the audience to come up on the stage, one by one, and cut a portion of her clothing (anywhere they like) and take it. The performer, however, does not have to be a woman.

BEAT PIECE

Listen to a heartbeat.

This was first performed in 1965 at the East End Theatre,
New York, by people coming on stage and lying on each
other's body to listen.

WIND PIECE

Make a way for the wind.

This was first performed in 1962 Sogetsu Art Center, Tokyo, with a huge electric fan on the stage. In 1966 Wesleyan University, Conn., audience was asked to move their chairs a little and make a narrow aisle for the wind to pass through. No wind was created with special means.

PROMISE PIECE

Promise.

This was first performed in Jeanette Cochrane Theatre in London, 1966. Yoko Ono, as the last piece of the night, broke a vase on the stage and asked people to pick up the pieces and take them home, promising that they would all meet again in 10 years time with the pieces and put the vase together again. Second performance was by a male performer in Tokyo calling a female performer in New York, 1964, at the Plaza Hotel; third performance by a solo performer calling a person in Kitazawa flat, 1962; fourth performance by a man in Chinatown phone booth, New York, calling a person at Chambers Street loft, New York, 1961; fifth performance, an elephant in Paris calling a parrot in New Guinea, 1959 — all calls being about future meetings. Call or write about future meetings or any other plans.

WHISPER PIECE

Whisper.

This piece was originally called a telephone piece, and was the starting of the word-of-mouth pieces. It is usually performed by the performer whispering a word or a note into an audience's ear and asking to have it passed on until it reaches the last person in the audience.

BREATH PIECE

Breathe.

First performed at Wesleyan University, Conn., U.S.A., in 1966. A large card with small lettering saying "breathe" was passed three times among the audience.

FLY PIECE

Fly.

This piece was first performed in Tokyo, Naiqua Gallery,
1964. Each person who attended the night flew in his/her
own way. It was performed again in London at Jeanette
Cochrane Theatre, by the audience who came up on the
stage and jumped off the different leveled ladders prepared
for them.

QUESTION PIECE

Question.

This piece, was first performed in Tokyo, 1962, Sogetsu Art
Center, by two people on stage asking questions to each other
and not answering. At the time it was done in French, but it
can be done in any language or in many different languages at
one time. The piece is meant for a dialogue or a monologue of
continuous questions, answered only by questions. It was also
performed in English on Voice of America Radio Program,
Tokyo, 1964, and in Japanese on NTV (Japanese Television)
by six children from the audience, 1964.

DISAPPEARING PIECE

Boil water.

This piece was first performed in New York, 1966, by only five people. This was not deliberate, but probably due to the subway strike in New York at the time. The water was boiled in a still, until it came out of the other side of the still, which took two hours. In London 1966, Mercury Theatre, the boiling of the water, the size of the pot in which the water was boiled, etc., was announced on the stage. The actual boiling of the water was performed at a Notting Hill Gate flat. The complete evaporation of the water was announced from the stage as the ending of the piece.

CLOCK PIECE

Usually a clock is placed on the center of the stage and
audience is asked to wait until the alarm goes off.

TOUCH PIECE

Touch.

This piece was performed many times in different places in
Europe, United States and Japan. Usually, the lights are put
off and the audience touches each other for ten minutes to
sometimes over two hours. In Nanzenji Temple in Kyoto,
1964, it lasted from evening till dawn. In London, people
started to whistle the theme song of "Bridge of River Kwai"
during the performance which became a chorus.

PROGRAMS

3 OLD PAINTINGS OF YOKO ONO
NAIQUA GALLERY

1st day June 7, 1964
5 a.m. – 11 a.m.
Painting to see the sky

2nd day June 14, 1964
5 a.m. – 11 a.m.
Painting to shake hands

3rd day June 21st, 1964
5 a.m. – 11 a.m.
Smoke Painting

No critics, art dealers
or dogs allowed

9 A.M. TO 11 A.M.

NAIQUA GALLERY
MAY 24, 1964
YOKO ONO

Wash your ears well before attending.

FLY
小 野　洋 子
場所: 内 科 画 廊
時:　4 月 25 日 (土)　8. P.M.

飛ぶ用意をして来る事。

TOUCH POEM NO. 3

place: Nigeria, Africa
time: March 33rd, 1964

Wash your hair well before
attending.

– Insound and Instructure –

P R O G R A M

sprout

motional

whisper

YAMAICHI HALL KYOTO JULY 20, 1964 from 6 P.M.
Tickets available at playguides.

Once we were fish
moving freely in the sea.
Our bodies were soft and swift
and we had no belongings.

Now that we crawled out of the sea
we are dry and full of cravings.
We wander city to city
carrying the memory of the sea
 (but it isn't just a memory).

Listen very carefully and you will hear
the sea in your body.
You know, our blood is seawater
and we are all seacarriers.

from "Seven Little Stories" 1st story
The Connection (original in Japanese)
spring 1952

TO THE WESLEYAN PEOPLE

To The Wesleyan People (who attended the meeting).
-a footnote to my lecture of January 13th, 1966.

When a violinist plays, which is incidental: the arm movement or the bow sound?

Try arm movement only.

If my music seems to require physical silence, that is because it requires concentration to yourself — and this requires inner silence which may lead to outer silence as well.

I think of my music more as a practice (gyo) than a music.

The only sound that exists to me is the sound of the mind. My works are only to induce music of the mind in people.

It is not possible to control a mind-time with a stopwatch or a metronome. In the mind-world, things spread out and go beyond time.

There is a wind that never dies.

xxxxxxxxxxxxx

My paintings, which are all instruction paintings (and meant for others to do), came after collage and assemblage (1915) and happening (1905) came into the art world. Considering the nature of my painting, any of the above three words or a new word can be used instead of the word, painting. But I like the old word painting because it immediately connects with "wall painting" painting, and it is nice and funny.

Among my instruction paintings, my interest is mainly in "painting to construct in your head". In your head, for instance, it is possible for a straight line to exist-not as a segment of a curve but as a straight line. Also, a line can be straight, curved and something else at the same time. A dot can exist as a 1,2,3,4,5,6, dimentional object all at the same time or at various times in different combinations as you wish to perceive. The movement of the molecule can be continuum and discontinuum at the same time. It can be with colour and/or without. There is no visual object that does not exist in comparison to or simultaneously with other objects, but these characteristics can be eliminated if you wish. A sunset can go on for days. You can eat up all the clouds in the sky. You can assemble a painting with a person in the North Pole over a phone, like playing chess. The painting method derives from as far back as the time of the Second World War when we had no food to eat, and my brother and I exchanged menus in the air.

There maybe a dream that two dream together, but there is no chair that two see together.

xxxxxxxxxxx

I think it is possible to see a chair as it is. But when you burn the chair, you suddenly realize that the chair in your mind did not burn or disappear. The world of construction seems to be the most tangible, and therefore final. This made me nervous. I started to wonder if it were really so.

Isn't a construction a beginning of a thing like a seed? Isn't it a segment of a larger totality, like an elephant's tail? Isn't it something just about to emerge — not quite structured — never quite structured . . . like an unfinished church with a sky ceiling? Therefore, the following works:

A venus made of plastic, except that her head is to be imagined.

A paper ball and a marble book, except that the final version is the fusion of these two objects which come into existance only in your head.

A marble sphere (actually existing) which, in your head, gradually becomes a sharp cone by the time it is extended to the far end of the room.

A garden covered with thick marble instead of snow — but like snow, which is to be appreciated only when you uncover the marble coating.

One thousand needles: imagine threading them with a straight thread.

<center>xxxxxxxxx</center>

I would like to see the sky machine on every corner of the street instead of the coke machine. We need more skies than coke.

<center>xxxxxxx</center>

Dance was once the way people communicated with God and godliness in people. Since when did dance become a pasted-face

exhibitionism of dancers on the spotlighted stage? Can you not communicate if it is totally dark?

If people make it a habit to draw a somersault on every other street as they commute to their office, take off their pants before they fight, shake hands with strangers whenever they feel like, give flowers or part of their clothing on streets, subways, elevator, toilet, etc., and if politicians go through a tea house door (lowered, so people must bend very low to get through) before they discuss anything and spend a day watching the fountain water dance at the nearest park, the world business may slow down a little but we may have peace.

To me this is dance.

<center>xxxxx</center>

All my works in the other fields have an "Event bent" so to speak. People ask me why I call some works Event and others not. They also ask me why I do not call my Events, Happenings.

Event, to me, is not an assimilation of all the other arts as Happening seems to be, but an extrication from the various sensory perceptions. It is not "a get togetherness" as most happenings are, but a dealing with oneself. Also, it has no script as happenings do, though it has something that starts it moving - the closest word for it may be a "wish" or "hope".

At a small dinner party last week, we suddenly discovered that our poet friend whom we admire very much was colour blind. Barbara

Moore said, "That explains about his work. Usually people's eyes are blocked by colour and they can't see the thing."

After unblocking one's mind, by dispensing with visual, auditory, and kinetic perceptions, what will come out of us? Would there be anything? I wonder. And my Events are mostly spent in wonderment.

In Kyoto, at Nanzenji Temples the High Monk was kind to let me use one of the temples and the gardens for my Event. It is a temple with great history, and it was an unheard of honour for the Monk to give permission for such use, especially, to a woman. The Event took place from evening till dawn. About fifty people came with the knowledge that it will last till dawn. The instruction was to watch the sky and to "touch". Some of them were just fast asleep until dawn. Some sat in the garden, some on the wide corridor, which is like a verandah. It was a beautiful full moon night, and the moon was so bright, that the mountains and the trees, which usually looked black under the moonlight, began to show their green. People talked about moonburn, moonbath, and about touching the sky. Two people, I noticed, were whispering all about their life story to each other. Once in a while, a restless person would come to me and ask if I was alright. I thought that it was very amusing, because it was a very warm and peaceful July night, and there was no reason why I should not be alright. Probably he was starting to feel something happening to him, something that he did not yet know how to cope with, the only way out for him was to come to me and ask if I was alright. I was a little nervous about people

making cigarette holes on the national treasure floors and tatami, from being high on the moonlight, since most of the people were young modern Japanese and some French and Americans. But nothing like that happening. When the morning breeze started to come in, people quietly woke up their friends, and we took a bath, three at a time, in a bath especially prepared for us at that hour of day. The temple bath is made of huge stone, and it is very warm. After the bath, we had miso soup and onigirl (rice sandwich). Without my saying anything about it, people silently swept the room and mopped the corridor before leaving. I did not know most of them, as they were mostly Kyoto people, and they left without giving their names. I wonder who they were.

At another time, also in Kyoto, before the Nanzenji Event, I had a concert at Yamaichi Hall. It was called "The Strip-tease Show" (it was stripping of the mind). When I met the High Monk the next day, he seemed a bit dissatisfied.

"I went to your concert", he said.

"Thank you, did you like it?"

"Well, why did you have those three chairs on the stage and call it a strip-tease by three?"

"If it is a chair or stone or woman, it is the same thing, my Monk."

"Where is the music?"

"The music is in the mind, my Monk."

"But that is the same with what we are doing, aren't you an avant-garde composer?"

"That is a label which was put by others for convenience."
"For instance, does Toshiro Mayuzumi create music of your kind?"
"I can only speak for myself."
"Do you have many followers?"
"No, but I know of two men who know what I am doing. I am very thankful for that."

Though he is a High Monk he is extremely young, he may be younger than myself. I wonder what the Monk is doing now.

Another Event that was memorable for me was "Fly" at Naiqua Gallery in Tokyo. People were asked to come prepared to fly in their own way. I did not attend.

xxx

People talk about happening. They say that art is headed towards that direction, that happening is assimilating the arts. I don't believe in collectivism of art nor in having only one direction in anything. I think it is nice to return to having many different arts, including happening, just as having many flowers. In fact, we could have more arts "smell", "weight", "taste", "cry", "anger" (competition of anger, that sort of thing), etc. People might say, that we never experience things separately, they are always in fusion, and that is why "the happening", which is a fusion of all sensory perceptions. Yes, I agree, but if that is so, it is all the more reason and challenge to create a sensory experience isolated from other sensory

experiences, which is something rare in daily life. Art is not merely a duplication of life. To assimilate art in life, is different from art duplicating life.

But returning to having various divisions of art, does not mean, for instance, that one must use only sounds as means to create music. One may give instructions to watch the fire for 10 days in order to create a vision in ones mind.

<center>x</center>

The mind is omnipresent, events in life never happen alone and the history is forever increasing its volume. The natural state of life and mind is complexity. At this point, what art can offer (if it can at all - to me it seems) is an absence of complexity, a vacuum through which you are led to a state of complete relaxation of mind. After that you may return to the complexity of life again, it may not be the same, or it may be, or you may never return, but that is your problem.

Mental richness should be worried just as physical richness. Didn't Christ say that it was like a camel trying to pass through a needle hole, for John Cage to go to heaven? I think it is nice to abandon what you have as much as possible, as many mental possessions as the physical ones, as they clutter your mind. It is nice to maintain poverty of environment, sound, thinking and belief. It is nice to keep oneself small, like a grain of rice, instead of expanding. Make yourself dispensable, like paper. See little, hear little, and think little.

The body is the Bodhi Tree
The mind like a bright mirror standing
Take care to wipe it all the time
And allow no dust to cling. — *Shen-hsiu*

There never was a Bodhi Tree
Nor bright mirror standing
Fundamentally, not one thing exists
So where is the dust to cling? — *Hui-neng*

SENSE PIECE

Common sense prevents you from thinking.
Have less sense and you will make more
sense.

Art is fart. Fart more and you will fart
less.

Screaming is a voice never loud enough
to reach. Scream more and you will scream
less.

1968 spring

LETTERS

Copy of letter sent to Ivan Karp

Jan 4, 1965

Jan. 4, 1965

Dear Ivan, - - - - -

- - - Why not have a strictly-for-the-artists
preview opening 'to draw a circle'? We will
invite only very selected artists-this is
vulgar, but vulgarity can be very interesting.
We will invite Bob Rauschenberg, Jasper Jones,
etc. Some old artists such as Max Ernst, Marcel
Duchamp, Isamu Noguchi are worth inviting.

I presume some of these artists are in
Europe - such as Max Ernst - we will invite them
with round-trip tickets, the expense of which
you can add to the price of the painting. Because
the painting, in short, will be a joint effort
of these artists. They will be asked to bring
means to draw a circle and to draw one on the
painting - a blank canvas, that is. Drawing a
circle shouldn't be so difficult a task for them,
and the idea of making a trip to your gallery
from wherever they are, just to draw a circle, is
very nice, I think.

I think painting can be instructionalized. Artist, in this case, will only give instructions or diagrams for painting -and the painting will be more or less a do-it-yourself kit according to the instructions. The painting starts to exist only when a person follows the instructions to let the painting come to life. From there on, the painting goes through a life of transformation, by people adding their own efforts to the painting according to or, sometimes, against the given instructions, thus taking an active part in the existence of the painting.

Imagine the "nail painting" hanging in the Museum of Modern Art with instructions saying "hammer a nail on it", and people coming every day to hammer nails of various sizes, and the painting, thus, changing its face every moment.

They don't have to be a Rauschenberg or Jones to draw the circles, or to hammer the nails.

I can just see a Bronxville housewife saying to her guests "do add a circle to my painting before you have a drink", or a guest saying, "I was just admiring your painting by taking the previledge of adding another hole

to it", etc. That is my dream, and something
to come very much later, I suppose.

Because of the method - the instruction
painting - many interesting things became
possible - such as creating a visual object
which is an interfusion of a physical and a
non-physical objects, etc. You will see these
instructions: long ones and short ones, in
the painting section of my book. I hope many
other instructions will come from people who
take up this idea of painting. Soon there will
be no need of artists, since people will start
to write their own instructions or exchange
them and paint.

But first, we should start with 'drawing
a circle", I think. We can also include the
following paintings for the preview opening.

1) draw your shadow on the canvas.
2) make a hole on
3) hammer a nail
4) draw a flower
5) erase or cut until there is no canvas
etc.

Also, the canvas to start the painting does
not have to be a blank canvas. They can be ready-made
paintings on which we can draw circles, flowers, etc.
Any painting will do. I can use from Da Vincci to
Warhole, that is, if you can supply them for me instead
of a blank canvas! I will enclose here two instructions
based on the paintings of these two artists. __ _ _ _ __

Nicholas Logsdail September 23, '67
Lisson Gallery
68 Bell Street
NW1

Dear Nicholas: Re: <u>Brief Meeting</u>

I think we could finally have the brief meeting we were discussing about. How about tomorrow night 8:15 p.m.? It will be very brief, naturally, as usual you are busy and I am nervous which amounts to the same thing. I cannot stay here longer than 20 minutes so please come on time.

It is best to come by foot, I think, since it is impossible to get a taxi around your place at that time. It is only a five minutes walk from your place. First you make a left turn at the end of your street on the right and go about 50 foot and turn right

(you will see a sign saying one way that is where you turn) and go until you see a coffee bar (not clean) on the left with a sign saying "closed" all the time but its not closed (you will see people in it) then you go through the narrow side-street of the coffee bar (this is a short cut) and you will come out naturally on May Street. From there its just a matter of walking straight on until you hit Park Road. My building is the one on the first left.

The above instructions are viewing the matter from my side, as it is too complicated to think from your side for me and I don't want it to be too confusing. So you will simply have to reverse the instructions where it says right to left and left to right, but otherwise this should get you to my place.

Hoping to see you then,

Sincerely,

Richard Bellamy December 18th, '66
c/o Goldowsky water
1078 Madison Ave.
New York, New York
U.S.A.

h.e.l.p.
give this message to someone on a balcony.

Mirror becomes a razor when it's broken.
A stick becomes a flute when it's loved.

from "Seven Little Stories" 3rd story
"Reincarnation" spring 1952
(original in Japanese)

A GIRL IN SUNSET

A beautiful thing happened to
a girl in sunset.
It was so beautiful she couldn't
get over it for a long time.
In fact, she's still going around
soaked in the same evening light—
carrying her orange past.
In daytime she looks like a cutout
from a Grand Canyon postcard.
At night she glows.
Then she's heard of a guy carrying
rain around him.

1968 summer

Other works by Yoko Ono — available only as
individual scores (inquire Bag Productions,
3 Savile Row, London W1)

Music Scores

OF A GRAPEFRUIT IN THE WORLD OF PARK — OPERA
STRAWBERRIES AND VIOLIN — OPERA
AOS — OPERA
THE PULSE — for String Quartet
PALM PIECE — for Voice Duet
QUESTION PIECE — for voice

Songs for soprano, and others
Songs for children
Songs for sick children
Songs to be sung under shower
Songs to be sung in bath

Songs to be sung in bed
Music to boil rice with
Music to bake bread with
Eggtimer Rondo

Objects

Smoke Objects
Shadows
Wish Pieces

Bagwear
Half Objects
Bottled Half-objects

Sky TV (from 9 furniture pieces, 1966)
a closed circuit T.V. set-up in the gallery for
looking at the sky.

Mirror To See Your Behind (from 9 furniture
pieces, 1966)

World Puller
Dawn Stone (A piece which should only be watched before
sunrise)
A Box of Smile
ETC.

Paintings

Some paintings, drawings & calligraphies

Tapes

Music Tapes
Tapes of Symposiums
Tapes of Events

Architecture

7 Building Ideas

Theatre Pieces

13 Theatre Scripts, and others

Films

Some films

LP Records

Poems

Touch Poems
Poems to be read in the dark
Poems to be read in candle light
Poems to be read at dawn
Poems to be covered by green
Poems to be aged
Poems to look for
Sand Poems
City Poems
Water Poems
Weight Poems
Poems to be read with a magnifying glass
Line Poems
Paper Poems
Follow-The-Dotted-Line Series
Questionnaires
London Winter Orgasm Game
Letter Cops

Stories

Children's Stories
Stories and songs for the very old
Stories and songs for the very fat
Stories and songs for the very lonely
Stories and songs for the ill-bred
Stories and songs for the over-sexed
Stories and songs for the cowards
Stories and songs for people with dandruff
Some more stories by Yoko Ono
Stories concerning Yoko Ono by others

Catalogues

Indica Gallery Show
Lisson Gallery Show
Film No. 4
Film No. 5 & Two Virgins
Film No. 6
Film "You Are Here"
Film "Selfportrait"
Bagwear "How and when to wear it" (New edition. Pamphlet
with photo illustrations)
Letters of some interest

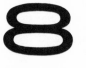 ARCHITECTURE PIECES
dedicated to a phantom
architect

1965 spring

Build a oneway seethrough house.
(use oneway mirror)

a) See through only from the outside
 so your life takes a form of a
 living confessional.

b) See through only from the inside
 so the city, the trees and the
 sky will be part of your house.

From 8 ARCHITECTURE PIECES DEDICATED
TO A PHANTOM ARCHITECT 1965 SPRING

Build a house
that serves only to
make way for the rain

Wetbed nice and cool to make
 love in
Spiral staircase for the rain to
run spirally
Rooms that change rain into different
fountains of various movements
Rooms that change rain into one hundred
pieces of happy music
A house that allows rain to be part of
it and therefore the thought of a rainy
day is not an unpleasant one anymore.

From 8 ARCHITECTURE PIECES DEDICATED
TO A PHANTOM ARCHITECT 1965 SPRING

Build a house
that serves only to make way for
moonlight

(Record chamber—to record moonlight
Smell chamber—to smell moonlight
Bathtub—very high up in the air for
moonbathing
Theatre—to operate people who've been
badly moonburnt
Storage room—with various cupboards
to keep and weigh moonlight—
etc.)

From 8 ARCHITECTURE PIECES DEDICATED
TO A PHANTOM ARCHITECT 1965 SPRING

Build a house
(on a hill)
that screams
when the wind blows

Open different windows that make
different screams and make different
air experiences in the rooms

From 8 ARCHITECTURE PIECES DEDICATED
TO A PHANTOM ARCHITECT 1965 SPRING

Build a house
on snow
with a glassbox base
which works as a snowsled
for winds to pull and slide (a)

Build a glassbox snowsled
and stay inside and watch—
Let the winds lead you to places (b)

From 8 ARCHITECTURE PIECES DEDICATED TO A
PHANTOM ARCHITECT 1965 SPRING

Build a dotted line house

Let people imagine the missing parts (a)
Let people forget about the missing
parts (b)

From 8 ARCHITECTURE PIECES DEDICATED
TO A PHANTOM ARCHITECT 1965 SPRING

Build a house
with walls which come into existence
only with the particular prism effect
created by sunset

If necessary, some walls or parts of
the walls can be made of material other
than light

From 8 ARCHITECTURE PIECES DEDICATED
TO A PHANTOM ARCHITECT 1965 SPRING

A floating city
The second level world
Upstairs on the clouds
Mountains and rain roaring underneath
Like venice, we have to commute by
boat through air currents to visit
eachothers floating houses.
Cloud gardens to watch all day.

From THE SOUNDLESS MUSIC (original
text in Japanese) 1950

DOOR PIECE

Make a tiny door to get in and out
so that you have to bend and squeeze
each time you get in . . . this will
make you aware of your size and about
getting in and out.

1964 spring

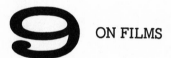

ON FILMS

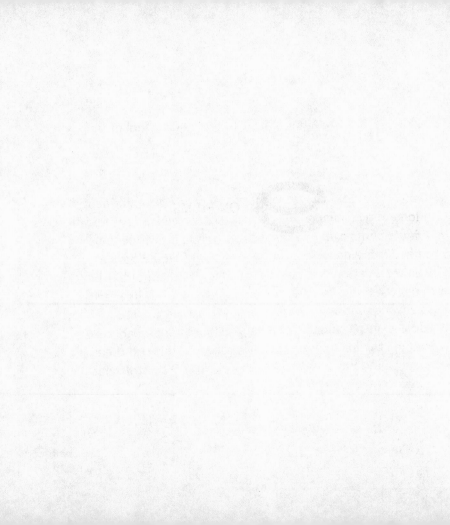

ON FILM NO. 4 (in taking the bottoms of 365 saints of our time)

I wonder why men can get serious at all. They have this delicate long thing hanging outside their bodies, which goes up and down by its own will. First of all having it outside your body is terribly dangerous. If I were a man I would have a fantastic castration complex to the point that I wouldn't be able to do a thing. Second, the inconsistency of it, like carrying a chance time alarm or something. If I were a man I would always be laughing at myself. Humour is probably something the male of the species discovered through their own anatomy. But men are so serious. Why? Why violence?

Why hatred? Why war? If people want to make war, they should make a colour war, and paint each others city up during the night in pinks and greens. Men have an unusual talent for making a bore out of everything they touch. Art, painting, sculpture, like who wants a cast-iron woman, for instance.

The film world is becoming terribly aristocratic, too. It's professionalism all the way down the line. In any other field: painting, music, etc., people are starting to become iconoclastic. But in the film world—that's where nobody touches it except the director. The director carries the old mystery of the artist. He is creating a universe, a mood, he is unique, etc., etc. This film proves that anybody can be a director. A

film-maker in San Francisco wrote to me and asked if he could make the San Francisco version of No. 4. That's OK with me. Somebody else wrote from New York, she wants to make a slow-motion version with her own behind. That's OK, too. I'm hoping that after seeing this film people will start to make their own home movies like crazy.

In 50 years or so, which is like 10 centuries from now, people will look at the films of the 60's. They will probably comment on Ingmar Bergman as meaningfully meaningful film-maker, Jean-Luc Godard as the meaningfully meaningless, Antonioni as meaninglessly meaningful, etc., etc. Then they would come to the No. 4 film and see a sudden swarm of

exposed bottoms, that these bottoms, in fact, belonged to people who represented the London scene. And I hope that they would see that the 60's was not only the age of achievements, but of laughter. This film, in fact, is like an aimless petition signed by people with their anuses. Next time we wish to make an appeal, we should send this film as the signature list.

My ultimate goal in film-making is to make a film which includes a smiling face snap of every single human being in the world. Of course, I cannot go around the whole world and take the shots myself. I need cooperation from something like the post offices of the world. If everybody would drop a

snapshot of themselves and their families to the post office of their town, or allow themselves to be photographed by the nearest photographic studio, this would be soon accomplished.

Of course, this film would need constant adding of footage. Probably nobody would like to see the whole film at once, so you can keep it in a library or something, and when you want to see some particular town's people's smiling faces you can go and check that section of film. We can also arrange it with a television network so that whenever you want to see faces of a particular location in the world, all you have to do is to press a button and there it is. This way, if Johnson wants to

see what sort of people he killed in Vietnam that day, he only has to turn the channel. Before this you were just part of a figure in the newspapers, but after this you become a smiling face. And when you are born, you will know that if you wanted to, you will have in your life time to communicate with the whole world. That is more than most of us could ask for. Very soon, the age may come where we would not need photographs to communicate, like ESP, etc. It will happen soon, but that will be "After the Film Age."

Yoko Ono
London '67

ON FILM NO. 5 & TWO VIRGINS

Last year, I said I'd like to make a "smile film" which included a smiling face snap of every single human being in the world. But that had obvious technical difficulties and was very likely that the plan would have remained as one of my beautiful never-nevers.

This year, I started off thinking of making films that were meant to be shown in a 100 years' time: i.e. taking different city views, hoping that most of the buildings in them would be demolished by the time the film was released; shooting an

ordinary woman with her full gear—knowing that in a 100 years' time, she'd look extraordinary, etc., etc. It's to apply the process of making vintage wine to film-making. This, in practice, would mean that as a film-maker you don't really have to make a film anymore but just put your name (that is, if you so wish) on any film and store it. Storing would then become the main endeavour of a film-maker. But then, the idea started to get too conceptual. That's the trouble with all my strawberries. They tend to evaporate and I find myself lying on the floor doing nothing.

One afternoon, John and I went out in the garden and shot Film No. 5, the smile film, and Two Virgins. They were done in a spirit of home movies. In both films, we were mainly

concerned about the vibrations the films send out—the kind that was between us. But, with Film No. 5, a lot of planning, working and talking out things had preceded the afternoon. For instance, I had thought of making Film No. 5 into a Dr. Zhivago and let it go on for 4 hours with an intermission and all that, but later decided to stick to a more commercial length of an hour (approx.). 8 m.m. copies of the film are also available for people who'd like to have the film on their wall as a light-portrait. Also, we'll store some copies for the next century.

They say that in the corner of the world there is a man who sits and spends his life in sending good vibration to the world, and when a star twinkles, we are only catching a twinkle that was sent 1000 light years ago, etc.

Imagine a painting that smiles just once in a billion years. John's ghostly smile in Film No. 5 might just communicate in a hundred years' time, or maybe, the way things are rolling, it may communicate much earlier than that. I think all the doors are just ready to open now. One light knock should do. It's just that there are still a minority group in the world who are afraid of the doorless world to come. They're just not sure how they can cope with it. But most of us know that doors are just figments of our imagination. The good thing is though, that law of nature that once you know, you can never unknow things, so the doors are going to disappear pretty rapidly, I think.

Some critic recently commented on us, John and I, as being

lollipop artists who are preoccupied with blowing soap-bubbles forever. I thought that was beautiful. There's a lot you can do with blowing soap-bubbles. Maybe the future USA should decide their presidency by having a soap-bubble contest. Blowing soap-bubbles could be used as a form of swearing. Some day the whole world can make it its occupation to blow soap-bubbles.

Would they ever know that Johnny West and Yoko DeMille ate bananas together?

October 22 '68
Yoko Ono

ON RAPE

Violence is a sad wind that, if channeled carefully, could bring seeds, chairs and all things pleasant to us.

We are all would-be Presidents of the World, and kids kicking the sky that doesn't listen.

What would you do if you had only one penis and a one-way tube ticket when you want to fuck the whole nation in one come?

I know a professor of philosophy whose hobby is to quietly crush biscuit boxes in a supermarket.

Maybe you can send signed, plastic lighters to people in place of your penis. But then some people might take your lighter as a piece of sculpture and keep it up in their living-room shelf.

So we go on eating and feeding frustration every day, lick lollipops and stay being peeping-toms dreaming of becoming Jack-the-Ripper.

This film was shot by our cameraman, Nick, while we were in a hospital. Nick is a gentle-man, who prefers eating clouds and floating pies to shooting "Rape." Nevertheless it was shot.

And as John says: "A is for parrot, which we can plainly see."

Yoko Ono
April '69, London